MONET

LIFE AND WORKS

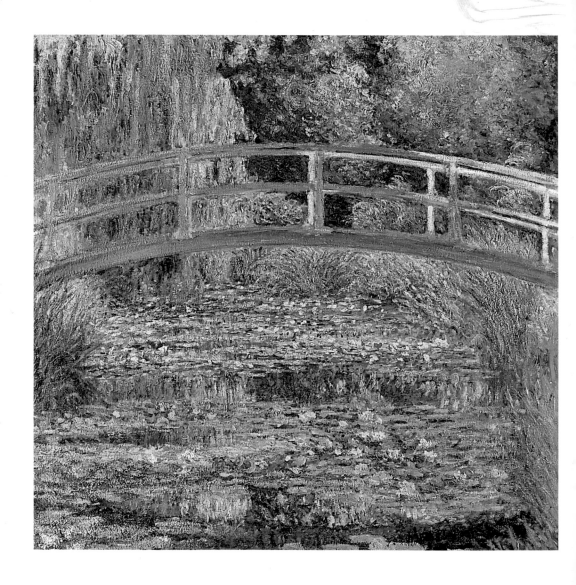

MONET

LIFE AND WORKS

MARIANNE SACHS

Series Editor: Ljiljana Ortolja-Baird

Editor: Andrew Brown

Designer: Bet Ayer

Sourcebooks, Inc.

P.O. Box 4410, Naperville, Illinois 60567-4410

(630) 961-3900

FAX: (630) 961-2168

Printed and bound in Italy

MQ 10 9 8 7 6 5 4 3 2 1

ISBN: 1-57071-691-9

Contents

Introduction

Born in 1840 and having died in 1926, Claude-Oscar Monet was the longest-lived of the Impressionists, and the most relentlessly productive. The catalogue of his oeuvre runs to more than two thousand items, some of them canvases on a very large scale. During 60 years of activity, Monet averaged in excess of 30 paintings a year, about one every 12 days. He had a capacity for grindingly hard work equaled by few artists and, blessed with a bulldozer physique, he was able to paint outdoors even in inclement conditions. Although his paintings, particularly in his early period, seem easy and spontaneous in accordance with the aesthetics of Impressionism, it was a spontaneity that, like the apparent effortlessness of a pianist, was the product of incessant practice of hand and eye. As he grew older, he often worked his canvases very heavily, in an attempt to understand and record the minutiae of nature's shifting lights and colors. Despite achieving an enormous reputation by the end of his life, he always remained dissatisfied, overcoming periods of despair by yet again returning to attack a new aspect of nature.

No account of Monet can be meaningful unless it appreciates that he was a painter of massive, but paradoxical, ambition. This paradox can be expressed simply: Monet aspired to produce painting that was grand, heroic, and timeless; but the subject matter he chose

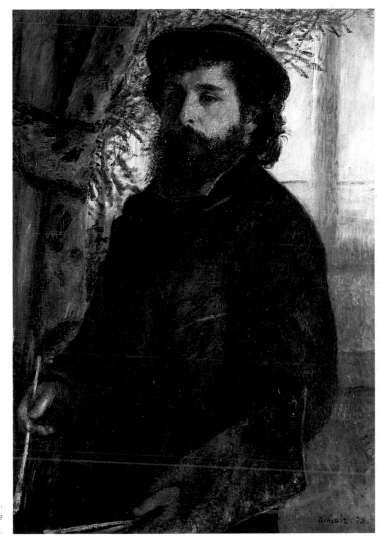

Pierre-Auguste Renoir,
*Portrait of Claude
Monet*, 1875.

was increasingly insubstantial, shifting, and evanescent. He achieved the majesty that he aimed for twice, at the beginning of his career and at the end, and although the forms in which he achieved it differ radically, the scale of ambition is constant. Monet's most obvious achievement was to define the central tenets of Impressionism – painting with unmixed colors, excluding black from the palette, attempting to seize instantaneous effects of nature, and registering the mutual modifications of colors – and to push them further than any other artist. The development of his technique into a supremely sensitive recording instrument was not an end in itself. Nor is his painting simply a record of particular locations: topography was not his objective, although many of his paintings are topographically precise. He always aimed for organized and poetic expressions of the lives of nature and man.

Monet's art had three foundations. One was a supreme sense of design: whatever his artistic sources – as his contemporaries noted, Japanese prints, with their strong, simplified surface organization, were always important for him – a capacity to organize a composition was present from the beginning. His arrangements of figures, or of the elements of still life or landscape, are more dramatic and powerful than those of his fellows. Simultaneously, his paintings function as abstract designs: they were often composed to a grid pattern, which allowed him to combine clarity of overall organization with maximum freedom of individual detailing. Monet's paintings possess a beauty and power independent of what they represent. On seeing an exhibition of the *Haystacks*, the young Wassily Kandinsky, later to become a great abstract painter himself, was profoundly moved by their coloristic effect, even before he could see what the paintings depicted.

The second foundation of Monet's art was his power as a draftsman. His earliest works were crayon caricatures of local worthies in Le Havre, where he grew up, and the

caricaturist's capacity to take quick likenesses, to fix salient features, and to sort the essential from the peripheral stayed with him. Although he left relatively few drawings, and many of those apparently slight, all display a firm sense of structure. Finally, and perhaps least expected, although color was central to his art, Monet was a great master of tone. This, too, goes back to his earliest years. As well as being influenced by Eugène Boudin, who introduced him to landscape and, especially, marine painting, Monet was encouraged by Jean-Berthold Jongkind. The Dutch artist's work affected him in many ways. For instance, Jongkind pioneered the use of broken brushstrokes, laying patches of paint side by side to evoke forms rather than describe them. Jongkind was often a clumsy painter, but he was an exceptionally accomplished maker of etchings, and from these Monet learned how to construct compositions in black and white. Underlying even Monet's softest work is a firm tonal organization: his paintings retain coherence in monochrome reproduction.

Complementing the underlying strength of arrangement in Monet's work is his rejection of anecdote and his relative detachment. Even intimate subjects, like his 1868 *Le Déjeuner* (*see pages 40 and 42–3*), a painting of his family at breakfast, are seen as though by a stranger: he refuses to allow sentiment to affect the judgments of the recording eye and the structuring mind. In 1879, Monet painted Camille, his first wife, on her deathbed (*see page 87*). He later said that despite his grief, he analysed the changes of color on her face rationally and objectively: the impersonality demanded by truth temporarily displacing the intensity of grief. The painting does not, in fact, seem detached or lacking in feeling: the image is tragic and haunting, the face under its veil already frozen and cobwebbed by death. But this effect could be achieved only by restraint, not by vehement emotion.

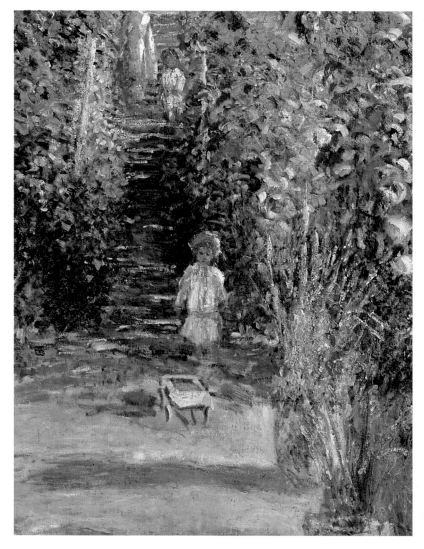

The Garden at Vétheuil, 1880 (detail; *see page 90*)

Monet's career falls fairly readily into stages, but these are never monolithic: he was always liable to turn aside to conduct a novel experiment. In the 1860s, although he painted seascapes and landscapes of great freshness and beauty, his central project was to become recognized as a figure-painter. Between 1865 and 1869, he produced some of the greatest figure-paintings of the 19th century, in which he treated subjects apparently without content – a group of friends picnicking in woods, women strolling in a sunlit garden, a family at lunch – with majestic seriousness, on the life-size scale generally reserved for paintings of major historical subjects. By doing so, he was following a trend pioneered by Gustave Courbet (1819–77), who painted very large canvases of personal subjects in the 1850s, and Édouard Manet (1832–83), who was trying to cast subjects from modern life in the mold of various old masters. But Monet's works lack the egoism and polemical tone of Courbet, and the self-conscious reference to tradition of Manet: they are, apparently, both natural and impersonal. These paintings, however, which cost enormous effort, were repeatedly rejected at the Paris Salon. Perhaps they seemed too democratic in subject – although there was nothing socially threatening about them – or too raw in execution. A single figure-painting, of Camille in a green dress (see page 33), was accepted at the Salon of 1866 and was highly praised, but that was all. Had Monet's work of the 1860s received its due, the subsequent history of European figure-painting might have been radically different.

These rejections pushed Monet towards landscape, and although he did not entirely abandon the human figure, henceforth it formed a thinning strand in his work. A rare exception was his flashy life-size painting of Camille in Japanese dress of 1876 (see pages 75 and 76–7), which was planned as a decorative panel. The work sold well, but even when in desperate financial straits, Monet never repeated such an exercise. Those later paintings

that include members of his family tend to use the figures as elements within arrangements, and his few specific portraits are unremarkable.

In 1870-71, during the Franco-Prussian War and the Paris Commune, Monet retreated to London, and then to Holland. His sympathies were, and remained, with the landscape traditions of northern rather than southern Europe. And they lay also with the comparatively democratic traditions of Britain and The Netherlands. Monet kept his distance from politics, but his views were consistent. He was a republican, of the moderate left, and his long friendship with the great radical statesman Georges Clemenceau indicates his sympathies and his intelligence. Thus, while a purely political reading of Monet's paintings would falsify them, he was clearly very sensitive to the national mood. The subject matter of much of his work of the 1870s demonstrates his pride in France's recovery after her catastrophic defeat by Prussia. His paintings of leisure exemplify relaxation and *joie de vivre*, and it is notable that he frequently turns for motifs to signs of reconstruction: the bridges at Argenteuil just outside Paris, which had been destroyed during the war, were painted by him both under repair and completed, their resurrection symbolizing France's returning power. His paintings of the Saint-Lazare railway station in Paris are poems to technology. And when, in 1879, Monet painted the June 30 celebrations in the rue Montorgueil, he embodied the energy and self-confidence of the young Third Republic in pictures whose vitality of execution matched their subject.

Yet the 1870s were personally gruelling for Monet. He and his friends, disheartened by repeated rejections at the Salon, set up an independent artistic society, which held its first exhibition in 1874. It was then that this loose group received the appellation 'Impressionists,' inspired by Monet's rather untypical *Impression: Sunrise* (*see pages 56–7*).

Little was sold, but successive exhibitions attracted increasing attention. And although Monet's financial straits were often desperate, his reputation gradually rose. In 1879, Camille died. Monet had, perhaps, already begun an affair with Alice, the wife of one of his principal collectors, Ernest Hoschedé. But after this low point, emotionally and financially, the tide gradually turned. In the early 1880s, the dealer Paul Durand-Ruel became a regular purchaser, and in 1883 Monet set up a household with Alice Hoschedé – whom he married in 1891 after the death of her husband Ernest – and their respective children at Giverny, near Chartres. Giverny remained the couple's home for the rest of their lives.

Apart from the paintings produced in Britain and Holland in 1870-71, Monet's sites had been largely confined to the Channel coast – to which he often returned – and various locations in and around Paris. But during the 1880s and 1890s, he voyaged extensively in search of inspiration. He went to the Mediterranean with Renoir in 1884 and again, alone, in 1889; he travelled to the far west of Brittany in 1886, where, for the first time, he painted truly wild landscape; in 1895, he went to Norway; and in 1900 and again in 1901 to London. Monet's restlessness was in part a consequence of his age: he wished to experiment with different sites and conditions, and to find more dramatic 'romantic' motifs, while he still had the energy and stamina to travel. But it was also a reaction to a problem. As he tried to capture the full mobility of nature, his technique had, inevitably, become increasingly broken. A tension had arisen between the brushstrokes used to evoke the forms of nature, the light upon them, and their ambient reflections and the textures, shapes, and substance of the paint itself. The method of depiction could sometimes disrupt pictorial wholeness. In some of Monet's least successful paintings of the 1880s, structure and definition weaken, and confusion is not always avoided. A way forward was to simplify his motifs, and to capture changing light in shorter sequences of time. And this naturally led to the inception

of the 'series paintings.' Although Monet had in the 1870s produced successive views of a subject – such as the Gare Saint-Lazare – around 1890, the series became central to his art. He painted multiple studies of the same motif, often at more or less the same angle, at different times of day and under different weather conditions. At the most extreme, he might work for only a few minutes at a time on one canvas, and then, as the light changed, take up another to register the different moment. And by focusing on more defined forms than in most of his work of the 1880s, Monet allowed himself a greater leeway: the atomization of a clear form, such as a haystack, the façade of Rouen Cathedral, a line of poplar trees – nature's nearest approximation to a row of columns – or Hungerford Bridge in London, did not disrupt the surface design or risk confusing the viewer, as when the same approach was applied to less substantial motifs.

But the subjects of Monet's series paintings were not chosen for their forms alone. They also held poetic and social meaning. The haystacks evoke the fecundity of France and the richness of its traditions; the façade of Rouen Cathedral, the treelike 'naturalness' of France's supreme architectural achievement, the High Gothic; the Houses of Parliament in London, seen through mist, with bright sunlight haloing Big Ben, powerfully symbolize constitutional government. Above all, however, when the series were seen together, as they were first exhibited, the rhythms of light and shade dissolving and re-creating forms across a group of images suggest the regular breathing of nature. Individual sonnets, combined in a sequence, acquire the extended grandeur of an epic in which, as never before in painting, duration becomes both a subject and a vehicle.

Increasingly, after 1900 Monet turned to water – beside which he had spent his youth – as his central interest. In 1908 he traveled to Venice, a city born from water, of which he

painted some of his most visionary canvases. But finally it was on his own garden at Giverny, its flower-beds, its bridge, and, above all, its lily-pond, that he focused. In some of his flower studies he still attempted too much – he never relinquished his ambition of making brushstrokes coincide with a multitude of small flickering forms – but it is of the pond that he made his most profound studies. Beginning with small, exquisitely beautiful renderings in the period 1904–7, he increasingly began to paint the water-lilies on a large scale. As he had once painted the human figure, Monet now painted nature at life size. His vast lily-ponds – from some of which all indications of banks, tree trunks, or foliage are omitted – are sites of reflection. By focusing on a single corner of nature Monet succeeded in evoking, in microcosm, an ordered universe. The lily-pads and their flowers become planetary bodies moving through air and water; the reflections of the rising or setting sun sometimes adding the element of fire.

Monet worked on his massive canvases throughout the First World War, often despairing before the difficulty of his task, preoccupied with the fate of France, and anxious that he was producing trivialities. He was sustained by the support of Clemenceau, whose responsibility for the nation's fate outweighed all others. To celebrate the Allied victory, at the close of his life, Monet gave to France a group of canvases to encircle two rooms of the Orangerie in Paris. In these rooms, the viewer is entirely immersed in foliage and water; they provide one of the most powerful effects of transcendence that Western painting can offer: a vision of creation, in which the individual ego dissolves and the viewer becomes as one with nature.

The Early Paintings

PAINTINGS OF THE 1850S AND 1860S

View at Rouelles 1858
18 x 25¼ in
Oil on canvas
Private Collection

Painted by Monet at the age of 18, this peaceful landscape displays an accomplishment and confidence extraordinary in a teenager. Its sweeps of varied, sleekly applied greens reveal his study of the preceding generation of painters, notably Charles-François Daubigny (1817–78), whose work the young Monet admired. But the rigor of the horizontal layering of earth, vegetation, and sky, and the central area of the painting where trees are reflected in the river, provide a significant anticipation of Monet's later interests. While river fishing is uncommon in his work, the treatment of leisure was to be one his central concerns: unlike the great Barbizon painters, Monet rarely showed people at labor.

Farmyard in Normandy *c.*1863

25¼ x 32 in

Oil on canvas

Musée d'Orsay, Paris

One of the painters to whom Monet first went for advice when he reached Paris in 1859 was the great animal painter Constant Troyon (1810–65). It may have been his example that encouraged Monet to paint a working farmyard, a subject to which he rarely returned. The barns on the left align as orthogonals in a standard perspective construction: they lead to the rear of the scene, where further depth is blocked by a hedge and tree-trunks. The striped sides of the farther barn introduce a major theme in Monet's work: whether he was painting women's dresses or the geological strata of cliff-faces, striping was one of his favorite devices for animating a composition.

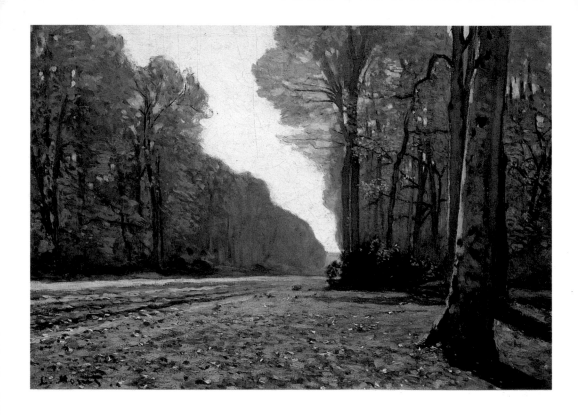

The Pavé de Chailly (formerly called
The Road to Bas-Breau) c.1865
17¼ x 23 in
Oil on canvas
Musée d'Orsay, Paris

Monet's bold painting shows the road from an unusually low
angle. The viewer is placed as though lying on the ground, close
to the tree on left. Monet repeated the same view from a little
farther off, a procedure that shows him, like a photographer,
shooting different angles of the same scene in search of varied
effects. In this it is easy to see a premonition of Monet's later
series paintings.

 Broad and simplified in execution, the surface is animated by
myriad dots of light on fallen leaves. The low angle allows the sky
to assume a positive shape between the rows of trees. The
straight road – which has an emotional value as well as a
pictorial one – was to become a major preoccupation of early
Impressionist painting, as opposed to the picturesque winding
tracks more popular in earlier landscapes.

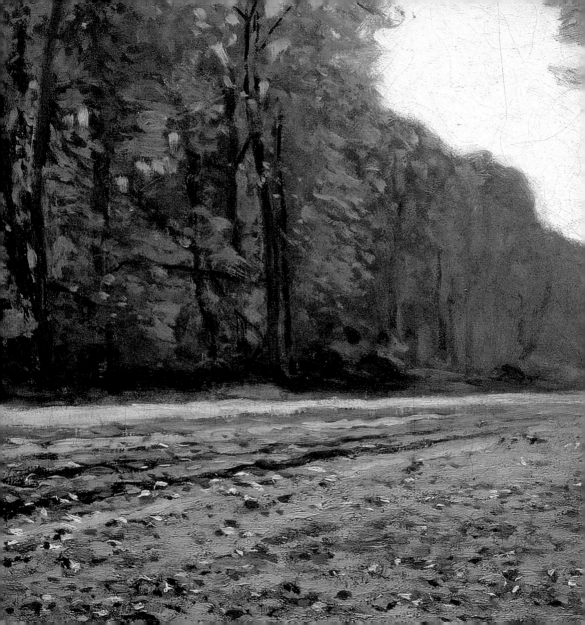

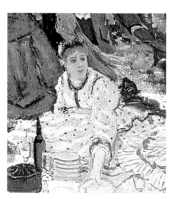

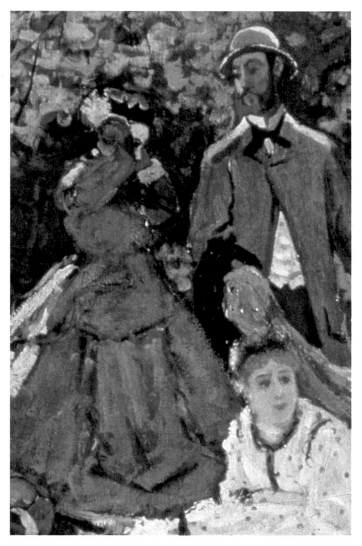

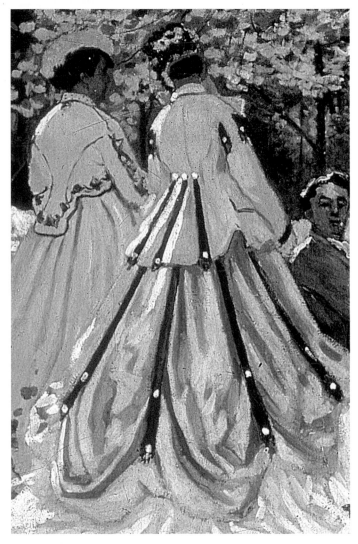

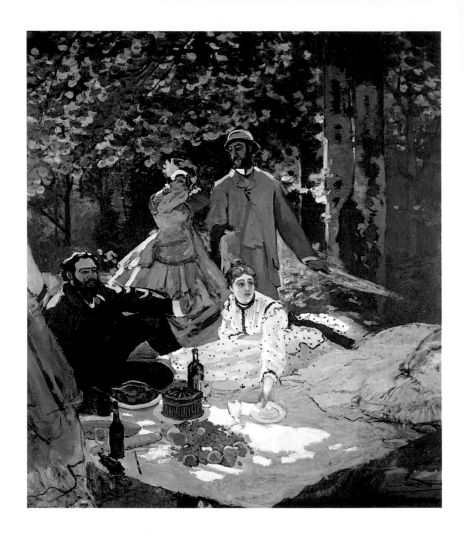

Lunch on the Grass (fragment) 1866

96¾ x 84¾ in

Oil on canvas

Musée d'Orsay, Paris

Monet planned to submit his vast *Déjeuner sur l'herbe* to the Salon of 1866, but was unable to complete it in time. He had to leave the unfinished picture with a creditor, and when he finally reclaimed it, the canvas had partly rotted. Monet cut it up, rescuing two irregular fragments, which he preserved to the end of his life.

Monet found a way of painting modern male costume effectively, by simplifying its forms in a tubular manner, and he set these against the flowing pyramids of the women's dresses. The private nature of the subject and the level of ambition recall Courbet's great *Atelier* of 1855, and Courbet, who encouraged Monet, probably posed for the seated bearded man. The woman handing out plates – the shared meal was a recurring theme for Monet – is the painter's mistress, the 18-year-old Camille Doncieux: she is lit from below, by reflected light from the sheet spread over the grass.

Camille, or the Woman in the Green Dress 1866

90 x 59 in

Oil on canvas

Kunsthalle, Bremen

Requiring a painting to show in the Salon of 1866, Monet painted Camille. He is said to have completed the picture in four days, and although this is exaggerated, it was certainly painted rapidly. Very unusually for Monet, there are technical lapses: for example, the edge of the floor now shows through Camille's skirt. Nevertheless, the painting was very well received, and Monet was commissioned by a Paris dealer to make a small replica.

The close viewpoint is unexpected, and the viewer is immediately implicated in the scene. The tapering of Camille's form lends prominence to the skirt and exaggerates the smallness of her face, creating a solidly pyramidal form, against which the turning, averted head acquires a sharp poignancy. The impression is of a heavy silk, and Monet conveys the movement and rustle of material, set in motion by her turning pose. The color control is magisterial: rich, dark greens set off the brightly lit face and hand, a traditional device in portraiture to draw attention to the most obviously expressive features.

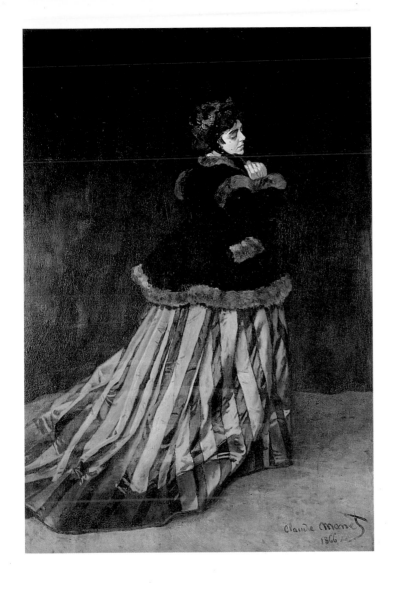

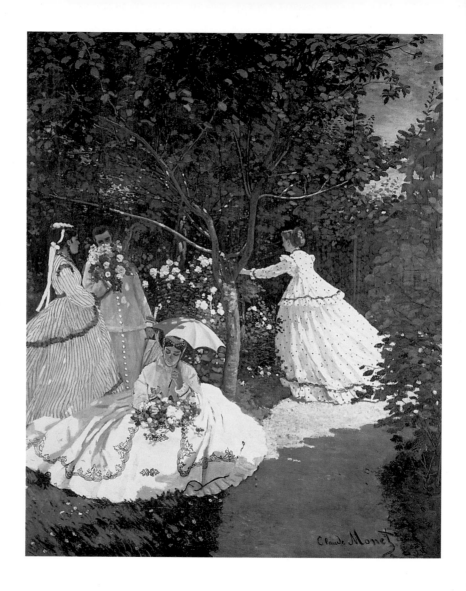

Women in the Garden 1867

99½ x 90 in

Oil on canvas

Musée d'Orsay, Paris

This painting, which was rejected at the Salon of 1868, seems to have no narrative. Monet evokes a dreamlike atmosphere, perhaps a fantasy Orient of geishas in a garden, acted out by Parisians. He creates an elegant rhythm of curves and countercurves among the costumes, the path, and the vegetation. The play of whites across the surface is immediately reminiscent of the work of James McNeill Whistler (1834–1903); but unlike Whistler, Monet is intent on capturing the effects of bright sunlight on juxtaposed fabrics. The arrangement of the figures exemplifies Monet's control: light-colored fabrics are placed in the strongest sunlight to enhance the highest tones, and nature's colors (less easy to master) are used for the darkest tonalities. The foreground shadow compels the eye into the middle ground, where the glowing white of the dress attracts us farther down the path. Monet was certainly affected by fashion prints, and he pays great attention to decorative detail, juxtaposing different patterns of garments.

Women in the Garden was bought by the painter Frédéric Bazille, but was later reacquired by Monet. In 1921 he finally sold it to the state, reversing its rejection half a century earlier.

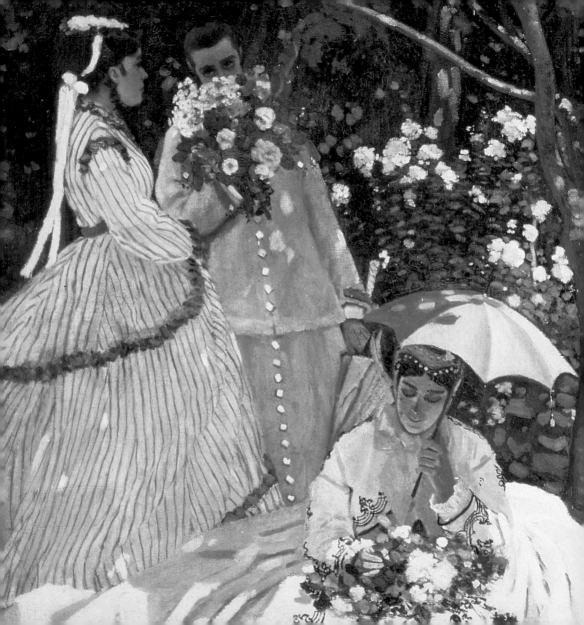

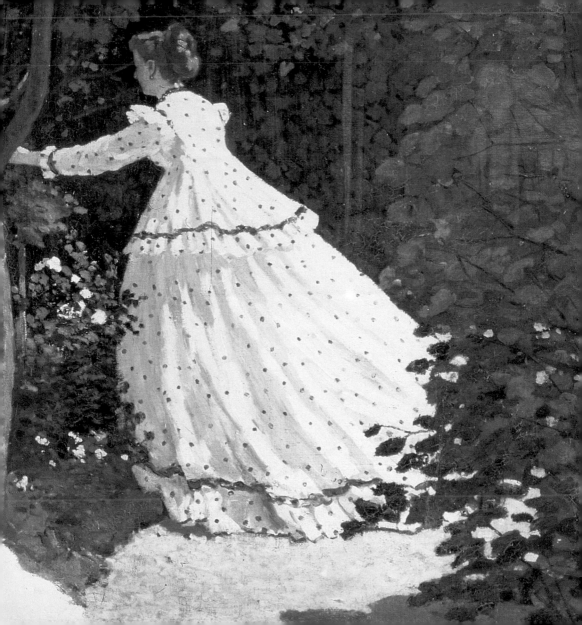

Terrace at Sainte-Adresse 1867

38¼ x 50¾ in

Oil on canvas

Metropolitan Museum of Art, New York

This painting's clarity of organization verges on the dogmatic, with the potentially disruptive dance of flowers controlled by a strict grid of verticals and horizontals. The colors are used in a pure and strong form, with red, green, and blue underpinned with the white of the costumes and the natural-toned terrace. The ground is treated like a carpet, bordered with greenery, and the painting demonstrates, with the rigor of a theorem, Monet's interest in the value of solid, unmodulated blocks of color found in Oriental prints – he later called this 'my Chinese painting with flags.'

The terrace is defined by the flag-poles and the balustrade; the sea is combed in regular waves, with a scansion of shipping. Monet's elderly father is seated at the lower right. The effect is a scene of retirement, a haven from which the sea becomes a spectacle for meditation.

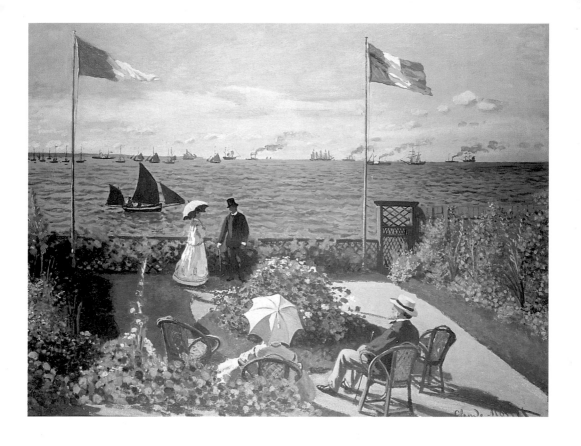

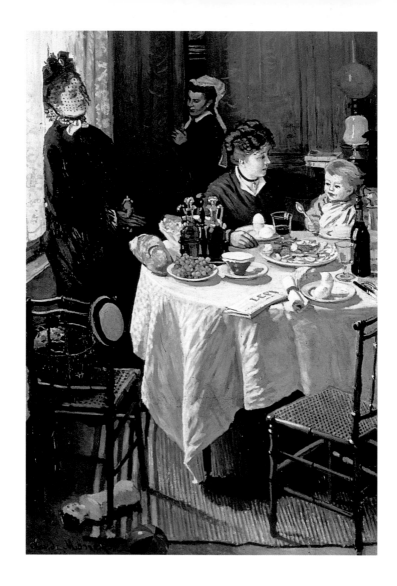

Le Déjeuner 1868

89¾ x 58½ in

Oil on canvas

Staedelsches Kunstinstitut, Frankfurt-am-Main

Exhibited as *Le Déjeuner*, this painting clearly represents an informal, relaxed moment before the meal begins, with a strong sense of what has just taken place and what is about to occur. The unidentified woman visitor, still wearing gloves and hat, stands by the window. The mother, Camille, is already seated at the table with the child, Jean, who is playing with his spoon. Both women's attention is on the child. Nothing on the table has been touched, for Papa – Monet himself – has not yet appeared. His arrival though is imminent: his place arranged, the napkin in its ring, the newspaper folded by his plate, his eggcup already filled. The maid hovers by the door. There is a combination of order and disorder in the home: the chair pushed back on the left, the doll abandoned on the floor beneath it (Jean's favorite doll, which Monet used more than once). This flow of time arrested in a glimpse of domestic routine owes much to 18th-century paintings of domestic interiors, particularly those by François Boucher (1703–70); but it is entirely modern in its use of a life-size scale. It was refused at the Salon of 1870.

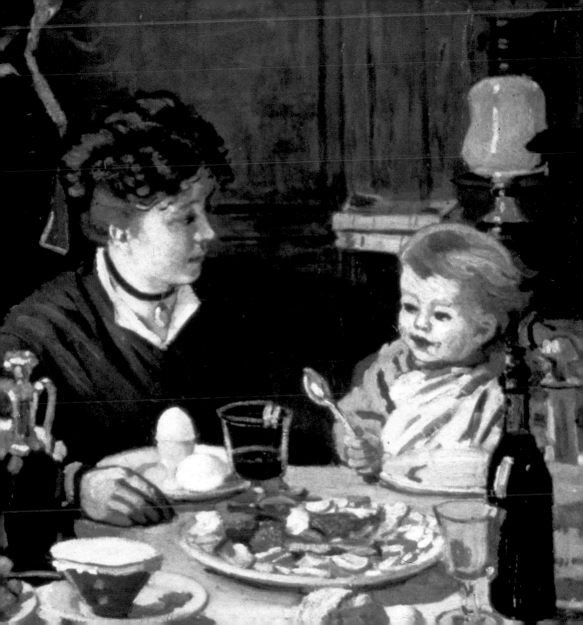

The Magpie 1869

34¾ x 50¾ in

Oil on canvas

Musée d'Orsay, Paris

Monet had painted several snow scenes in previous years, generally with overcast skies. *The Magpie* is very different. Although snow lies thickly on the ground and on the fence, the bright sunlight gives the scene an exhilarating freshness and vitality. The horizontal of the fence bisects the canvas, and severe verticals of bare trees rise above it. But the painting does not seem rigid: the sun throws angled shadows on the carpet of snow in the foreground, which set up a lively syncopated rhythm in the bottom half of the painting. But it is above all the magpie, perched on the gate, that catches the eye. Its dramatic plumage seems to encapsulate the painting's mood as well as its coloring, and the bird's position, off to one side, provides a cheeky counterpoint to the geometricality of the whole. The magpie seems about to take wing, and the viewer's spirits will soar with it. Monet rarely used birds or animals to animate his paintings, but here he does so with triumphant success.

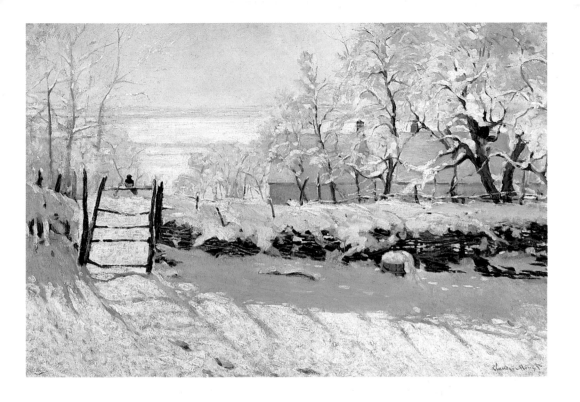

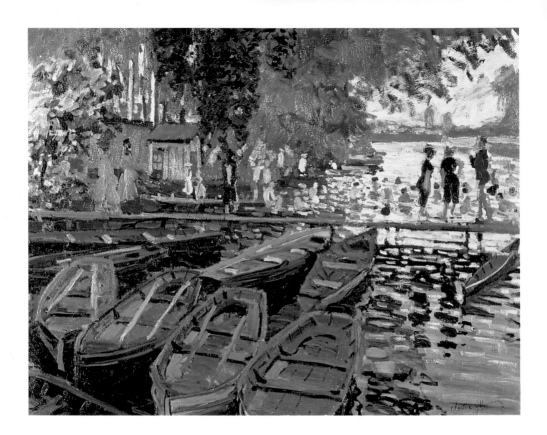

Bathers at La Grenouillère 1869

28½ x 36 in

Oil on canvas

National Gallery, London

This painting was one of two substantial and several smaller studies made at the fashionable bathing and boating place on the Île de Croissy, favored in the 1860s by daytrippers. At this time, Monet and Renoir were working together, and this composition marks the beginning of their focus on suburban leisure. From the bathing huts on the left a footbridge leads to the round floating platform known as the 'Camembert.' A second footbridge connected this to the floating café La Grenouillère – not visible in this canvas. Monet's studies were planned for a large picture that was never executed, although he did paint a medium-sized version – now destroyed.

Although conceived as sketches, this painting and its companions had a profound effect on Monet's later work. The alignment of forms is clear and strong, and the animation of the figures shows that Monet's rapid caricatural skill had not deserted him. Brushstrokes are used as building blocks. The brush changes gear to evoke different objects: rich application establishes contrasts of tone in the sunlit trees, and drier strokes in the overhanging foliage register the stirring of the leaves.

The 1870s

PAINTINGS BETWEEN 1870 AND 1879

The Hôtel des Roches Noires at Trouville 1870

31½ x 23 in

Oil on canvas

Musée d'Orsay, Paris

It is barely conceivable that this picture was painted during the
Franco-Prussian War, such is its vitality and verve,
communicated in part by the sharp contrasts of shadows and
light. Monet employs an oblique view, catapulting the eye into the
distance, which is suddenly blocked by a marquee. The canvas
is based on diagonals, and it separates into two triangular
sections – the right side dominated by soft yellows and whites,
the left by brilliant blue animated with streaks of red of the
fluttering flags. To keep the tonal key high, Monet uses the lighter
palette in the shadows and the darker colors in the bright
sunlight. Broken brushstrokes are largely limited to the vivid
flags, which snap in the wind. They, too, are chosen to be part of
the compositional structure, with the horizontals of the Stars and
Stripes set above the verticals of the Tricolor.

The Thames below Westminster 1871

18¼ x 28½ in

Oil on canvas

National Gallery, London

One of Monet's most severely geometrical compositions, this
painting shows the influence of Japanese prints and also,
probably, that of Whistler, a pioneer of *japonisme* with whom
Monet would automatically have associated views of the
Thames. Monet was unafraid to depict 'tourist' sites, and here he
observes the Houses of Parliament, viewed from the newly
constructed Westminster Embankment. But his painting pays at
least as much attention to the skeletal jetty in the right
foreground, whose structure is dramatized by silhouetting, and
which is given greater solidity than the mass of buildings behind,
which are softened by the mist. Here, the Houses of Parliament
are a component of an arrangement: when Monet returned to
paint them 30 years later his treatment was much more visionary
(*see page 124*).

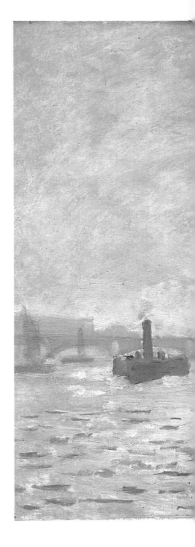

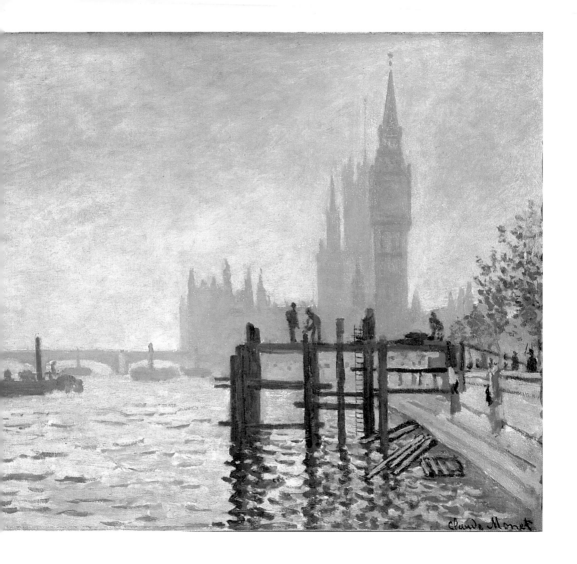

Claude Monet

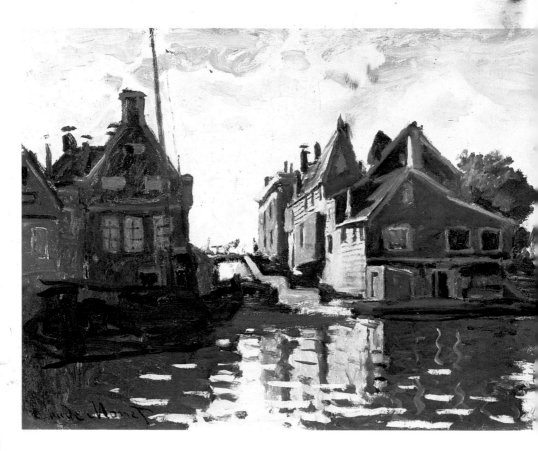

Zandam 1872

17¼ x 28½ in

Oil on canvas

Private Collection

Monet divides the middle ground into a tripartite arrangement, with a strong central feature in the pitched-roof houses, and flanking buildings at either side. The painted houses are treated in patches of strongly lit color applied in broad, vigorous planes. In the foreground, their reflections in the water are interrupted by wide horizontal dashes, and the reflected chimneys and masts suddenly zigzag, registering a ruffling breeze. This technique creates a distinctively glassy effect of surface, quite different from his later renderings of water with broken brushwork. In the sky, curling strokes indicate the swirl of clouds. In placing the solid forms in the upper part of his painting, Monet has simultaneously emphasized the life and movement of the water and contained it. He evokes as well as any Netherlandish painter the conjoined lives of land and water

in this Dutch port.

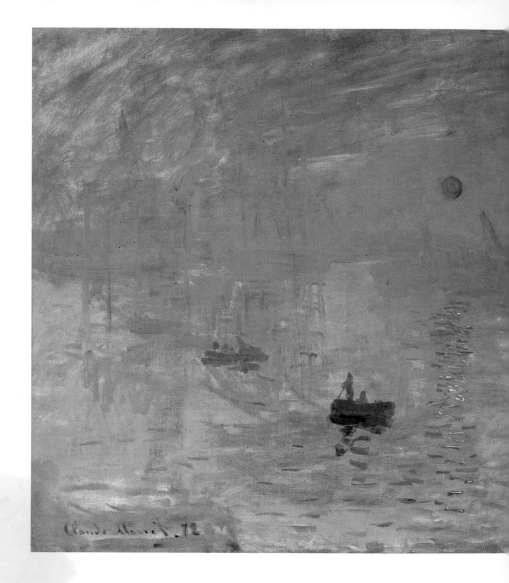

Impression: Sunrise, Le Havre 1872

18¾ x 24½ in

Oil on canvas

Musée Marmottan, Paris

Unexpectedly, this painting gave the Impressionist movement its name, one that Monet soon accepted. But the painting is far from typical of his work of the time, and it is evident that he intended it as a study rather than as a developed statement. It was not uncommon even for academic artists to show studies as adjuncts to finished pictures.

Impression is the loosest of the six paintings that Monet exhibited in 1874, although its structure is inspired by a Jongkind etching. In its treatment of sun rising through vapor, it recalls Turner, whose work Monet saw in London, and, in its strongly 'aesthetic' mood, Whistler, whose work Monet admired. Its poetry of reds and purples shows the transforming power of light and color to create an image of Le Havre as memorably beautiful as a morning in Venice.

The 1870s

The Marina at Argenteuil c.1872

23½ x 31½ in

Oil on canvas

Musée d'Orsay, Paris

In this, one of the classic Impressionist paintings, Monet depicts a clean bright day in blue, white, and green. The subject is almost a skyscape: the greater part of the painting is occupied by a sky filled with scudding white clouds. Transverse shadows fall like bars across the path, marking its recessions so clearly that we feel we can measure its depth. Cast by the regularly spaced trees on the left, they play against the verticals of their trunks. The viewer is distanced from the scene and the strolling family, which is small in relation to the landscape. But there is an abiding sense of relaxation, of harmony between the figures on the left and their aquatic counterparts, the sailing boats, on the right. Once again, this most energetic of painters chose repose and relaxation for his subject.

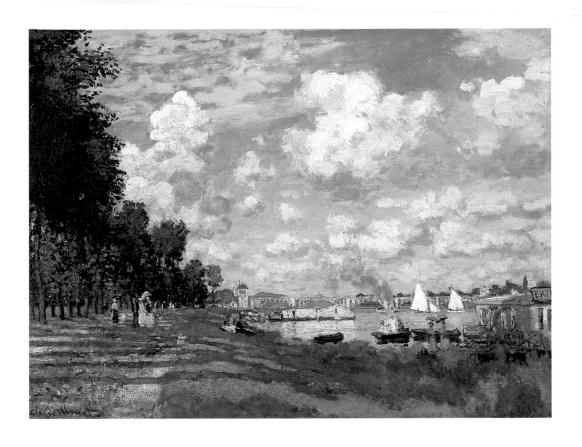

Wild Poppies near Argenteuil 1873

19½ x 25¼ in

Oil on canvas

Musée d'Orsay, Paris

The figures of mother and child are now taken outside the confines of the home and the riverbank and into the fields. They are subordinated to nature, but nevertheless placed in key positions in the construction of the painting. There are two groups of a woman and a child, one at the top of bank, the other at the bottom: their relation indicates a slanting path, concealed by the long grass. As in other paintings by Monet, they are probably the same models, but placed in different positions.

The painting is an example of Monet's consummate skill in organizing dissolving forms within a subtle but clear structure. Dark colors of the figures would be lost in the high grass, but they are deftly brought to the viewer's attention and become pivotal points by a mere dab of white for their hats – that of the little boy in the foreground is lined up along a grassy gully with the house in the far distance, pulling foreground and background together. The touch is softer than usual with Monet, and was perhaps affected by his frequent contact with Renoir at this time.

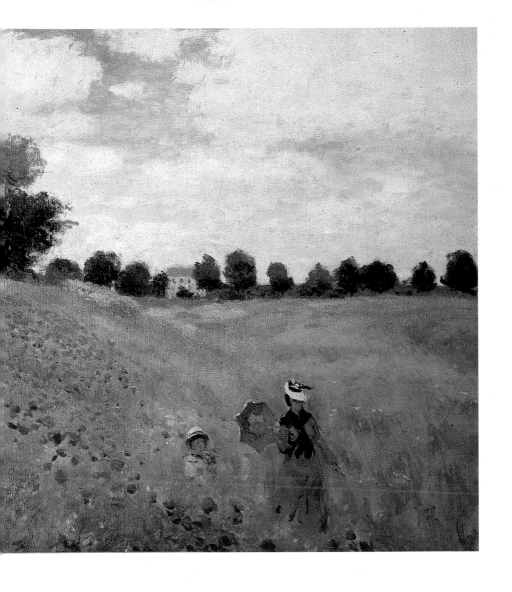

The Luncheon: Monet's Garden at Argenteuil *c.*1873

62½ x 78½ in

Oil on canvas

Musée d'Orsay, Paris

When it was first shown in 1876, this calm and civilized painting of a summer's afternoon was described as a decorative panel, but it is not known for whom it was painted or where it was planned to be installed.

There is a profusion of color. The insubstantial flowers and leaves are made solid by paint, built up of a multitude of colored dabs. Unlike *Le Déjeuner* (*see pages 40 and 42–3*), where the meal has not yet begun, here it is finished and the lunchers – Camille and a friend – have got up to stroll about the garden. We can glimpse them in sunshine on the path behind the flower-beds, while we have been left under an arbor, having pushed our chair back a little from the abandoned table, to watch over the child – Monet's son Jean – quietly playing on the ground. Everything suggests the lunchers have only recently risen – a napkin tossed untidily onto the table, two wine glasses not quite drained, a parasol left casually on the bench, the straw hat forgotten, hanging from a convenient branch. Monet achieves a remarkably palpable presence, his camera lens sectioning the flow of time.

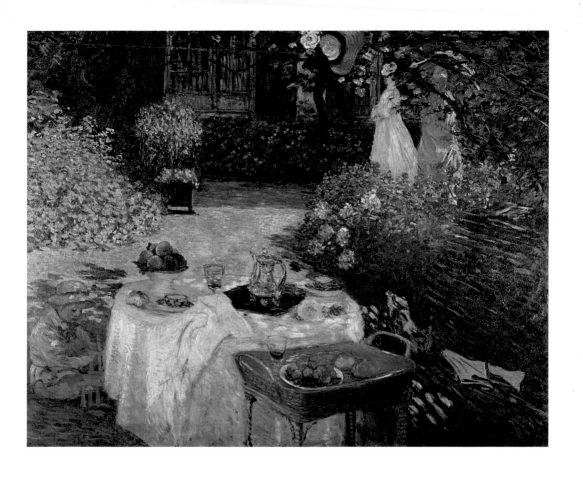

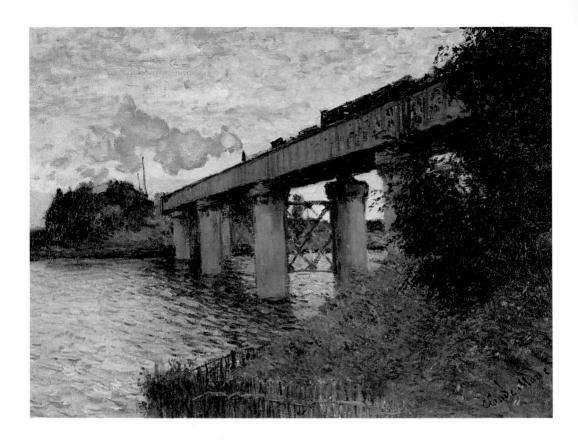

The Railway Bridge at Argenteuil 1873–4

21½ x 28 in

Oil on canvas

Musée d'Orsay, Paris

In 1870, during the Franco-Prussian War, the railway bridge at Argenteuil was blown up. Contemporary photographs of the shattered structure and the twisted rails make clear the visual violence of the destruction and, by contrast, the healing emotional effect of its reconstruction.

Here the new bridge is shown in dull weather; Monet also painted it from the same angle in bright sunlight in a picture now in Philadelphia. There is a sense of France's returning vigor in these paintings, which is also expressed in the strong composition.

We see little of the train, only the tops of the trucks and the tip of the engine's funnel. Monet concentrates attention on the billowing smoke, which, like a flag, takes our eye into the far distance. The soft and evanescent are placed beside the hard and the permanent. The reflections of the bridge's supports in the water are undefined shapes in the dull light, unlike the sharply defined reflections in the Philadelphia picture. The painting is enlivened with a remarkable range of muted whites – crests of ruffled water, areas of the bridge, smoke, clouds – all rendered with varied brushstrokes.

The Bridge at Argenteuil 1874

23¾ x 31¼ in

Oil on canvas

Musée d'Orsay, Paris

Like the railway bridge, the road bridge at Argenteuil was also destroyed in 1870, but the viewer would have no inkling of this. The scene could hardly be more peaceful. The boats are moored on a bright summer's afternoon, and there is an absence of human activity.

Monet's central preoccupation here is water and its reflections: the dominant theme of his last paintings. He magisterially resolves a tension between the descent of the eye into depth and its movement across the painting. The water is built up from short, rather square, brushstrokes, creating a slightly jerky progression, which balances surface and depth. Where we might be in danger of losing the sense of the surface – for example, by the interruption of the vertical edge of the reflected house at the far end of the bridge – and of plunging too deep, the horizontal booms of the foreground dinghies cut across the composition and restore it to us.

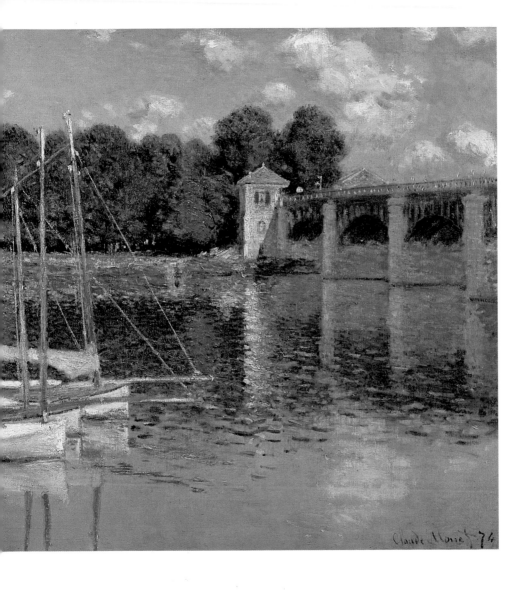

Claude Monet 74

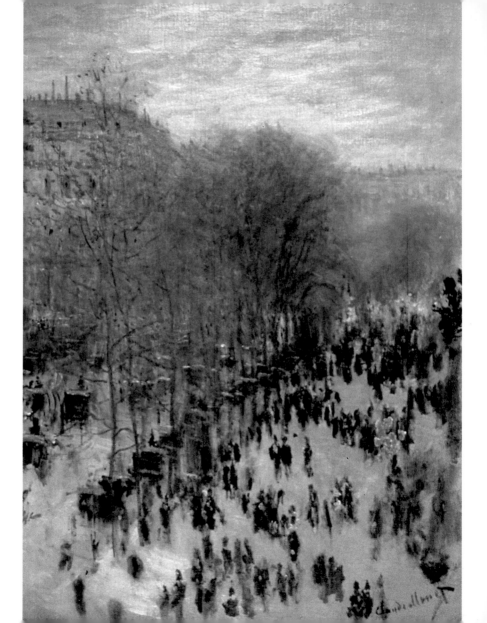

The Boulevard des Capucines 1873

31¼ x 23½ in

Oil on canvas

Nelson-Atkins Museum of Art, Kansas City

This winter cityscape, a new motif for Monet, was taken from a window of Nadar's gallery. From this bird's-eye perspective, all objects – people, trees, and buildings – become generalized. Working with a restrained, sombre palette of predominantly gray, blue, black, and white – except for the splash of red on the right depicting a cluster of balloons – everything, including the large apartment buildings behind the trees in the background, is treated as evanescent. The blurring of edges, perhaps the effect of mist on the window, links Monet with Renoir, who also employed this technique. The diffuse and mobile elements are held firmly together by the rigor of the design: the division of the surface into two triangles, one of Monet's favorite devices for clarifying structure, and the zigzagging framework of figures evoked by a myriad of black and gray dabs and a few specks of red.

The Boulevard des Capucines 1873

23¾ x 31¼ in

Oil on canvas

Pushkin Museum of Art, Moscow

The same boulevard is viewed here in autumn colors. But the painting's organization is consciously different from the winter version. Although Monet employed an identically sized canvas, he used it here horizontally so that the two paintings do not seem to be a pair. In this autumnal version, the viewer is brought lower, much closer to the boulevard. The division into two triangular sections is still pronounced – the right-hand section is in shade, the left in sunlight. Although, as the change in seasons indicates, some time has elapsed between each depiction, the two gentlemen in stove-pipe hats leaning out from a balcony at the right of the picture appear again, now looming almost in front of the observer, as though Monet was using a zoom lens. Their presence, in positions that could not have been held for long, enhances the sense of immediacy.

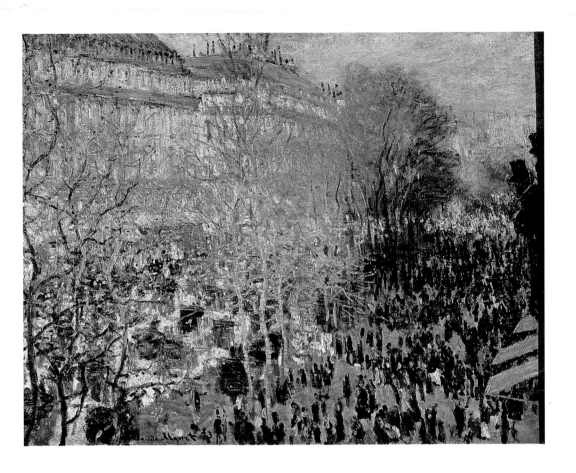

***Camille Monet in Japanese Costume,
or The Japanese Girl*** 1876

90 x 55½ in

Oil on canvas

Museum of Fine Arts, Boston

Shown in the second Impressionist exhibition in April 1876, where
it was described as a decorative painting, this picture sold well at
an auction of Monet's works in the same month. Camille, in a
blond wig, posed for the picture, a piece of self-conscious
play-acting, of a sort that Renoir also experimented with in his
treatments of Lise. Despite the painting's success, Monet seems
to have regarded it as a pot-boiler, and never repeated the
exercise. But it is not wholly lightweight. It is very well organized
as a fugue on the theme of fans, both Japanese and Western,
folding and unfolding in a bold sequence that also includes
Camille's body. Unusually for Monet, the painting has an erotic
edge: the ferocious samurai embroidered over Camille's hips
was noted by at least one commentator – it seems to embody a
warning that her invitation is not what it appears.

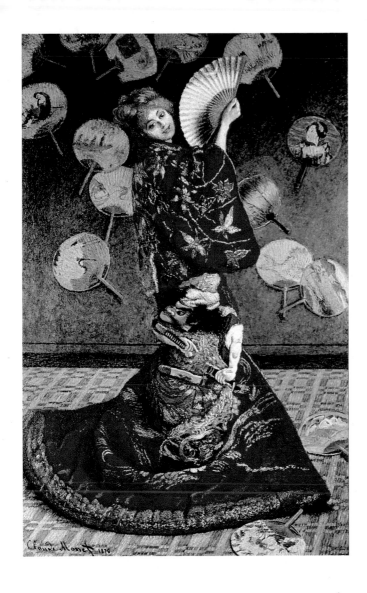

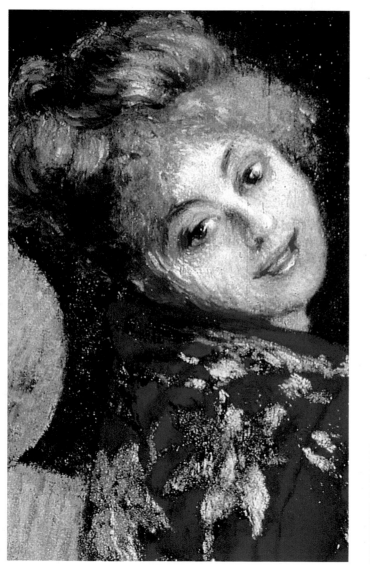

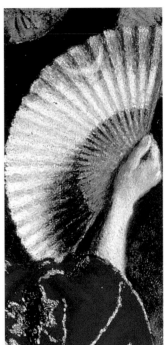

Gare Saint-Lazare 1877

29¾ x 40½ in

Oil on canvas

Musée d'Orsay, Paris

In 1877 Monet painted a dozen views of the Gare Saint-Lazare in Paris. Some are taken from within the station sheds, others from outside. They vary from quite casually composed paintings to strongly geometrical ones: in the present picture, the pitched roof, slim supporting struts, and network of horizontal spars irresistibly evoke a Gothic cathedral. These paintings demonstrate a full acceptance of modernity: indeed, they celebrate the age of steam. But it was characteristic of Monet to counterpoint the rigidity of the structure with the evanescence of smoke. He treats the engines, made insubstantial by the vapor that obscures them, as though they were boats, coming into and out of harbor. The viewer's eye is drawn from the shadowed foreground into the bright sunlight beyond, establishing an emotional as well as a physical relation with the scene.

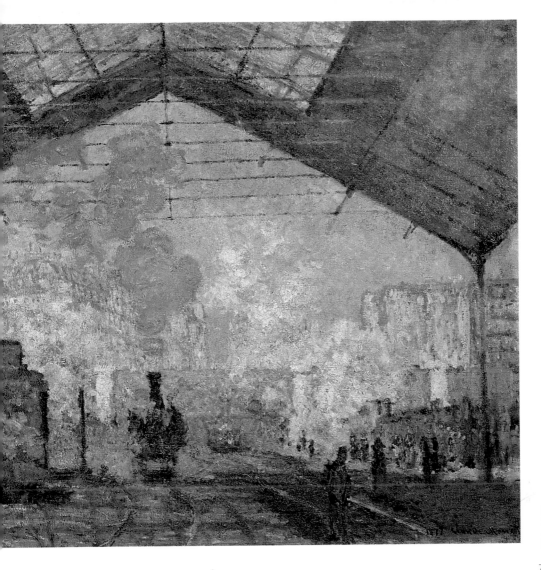

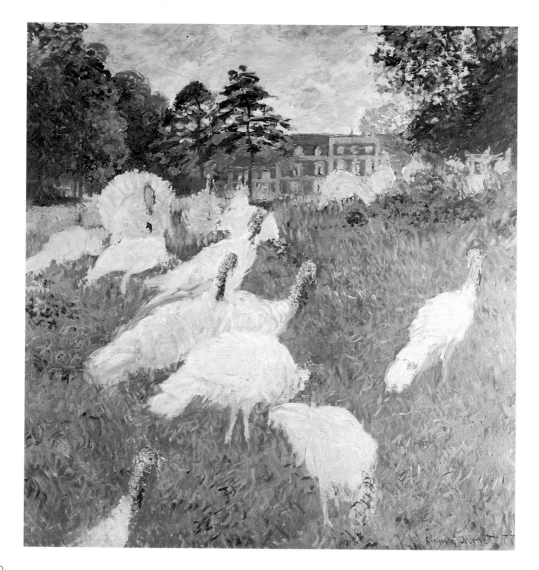

The Turkeys at the Château de Rottembourg 1877

68¼ x 67½ in

Oil on canvas

Musée d'Orsay, Paris

This arresting image is one of four decorative panels painted for the Villa of Montgeron, which was owned by Ernest Hoschedé. They showed views of its gardens and of various activities in and around the country estate. This painting must have particularly surprised Monet's contemporaries; for not only did Monet rarely paint living animals and birds on a large scale – although he occasionally painted still lifes of game – but also his subject is rare, even in French bird painting of the 18th century, when the vogue reached its height. Monet's approach at once counters and revitalizes this tradition. The turkeys, brought close to the spectator, are treated in stately mode, their huge white forms gracing the lawn like peacocks. The contrast of shadows and strong light suggests a hot summer's afternoon with the sun still high.

The Rue Montorgueil, Paris: Celebration of 30 June 1878

31½ x 20 in

Oil on canvas

Musée d'Orsay, Paris

The painting celebrates the vitality of the young Third Republic at the opening of the Universal Exhibition of 1878. Monet covers the picture surface with flags, a motif he had treated earlier but never in such abundance. Similar to the depictions of the Boulevard des Capucines, the street is shown from a high viewpoint: but here the intense colors electrify the air. The eye moves inwards but is continually interrupted and blocked by the multitude of flags. The atmosphere of excited movement is evoked by different types and directions of brushstroke that at once describe and orchestrate the composition – for example, the red dabs, whose ragged edges made with a rather dry brush suggest the fluttering of the festive flags also bounce the eye back and forth along the wall of bunting.

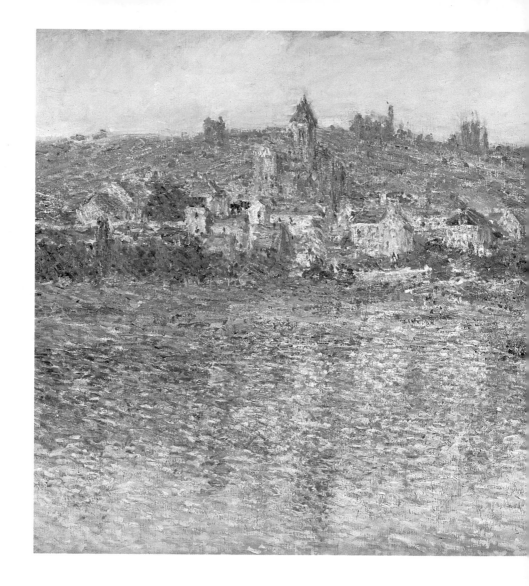

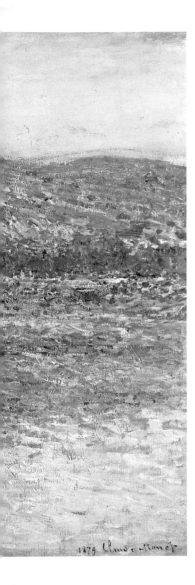

Vétheuil in Summertime 1879

26½ x 35 in

Oil on canvas

Art Gallery of Ontario, Toronto

In 1878, at a particularly stressful period in his life, Monet moved with his family to the village of Vétheuil, where he rented a house. He painted several versions of the village seen across the water from more or less the same viewpoint on the Île de Moisson. This is one of the most distant and most centralized views, and it focuses attention on the church, surrounded by houses that appear to grow out of it and spread down to the water's edge. Monet had used churches as focal points in his work before, but here the building's organic centrality seems to endow it with symbolic weight. Though a rationalist, it is possible that Monet sought some religious solace during this time of deep anxiety over his wife's health.

Camille on her Deathbed 1879

35 x 26½ in

Oil on canvas

Musée d'Orsay, Paris

Camille died at Vétheuil on September 5, 1879, at the age of 32, probably from uterine cancer. In painting a last view of her, Monet was following a tradition: it was believed that Tintoretto painted his daughter on her deathbed, and this became the subject of a famous picture of 1843 by Léon Cogniet (1794–1880); and in 1918, Franz Hödler made a shattering series of drawings and watercolors of his dying wife. There is a splinter of ice in the heart of the painter, but Monet's vision of his wife is far from clinical: the pillows are arranged as if to suggest a bridal veil, and her head seems to float against them like Ophelia in the water. The predominant purples and whites suggest twilight, and snow and frost seem to be taking possession of Camille, her form becoming spectral.

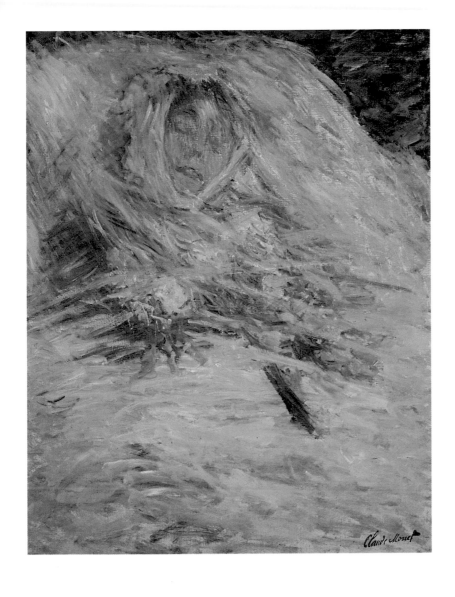

Claude Monet

The 1880s and 1890s

PAINTINGS BETWEEN 1880 AND 1894

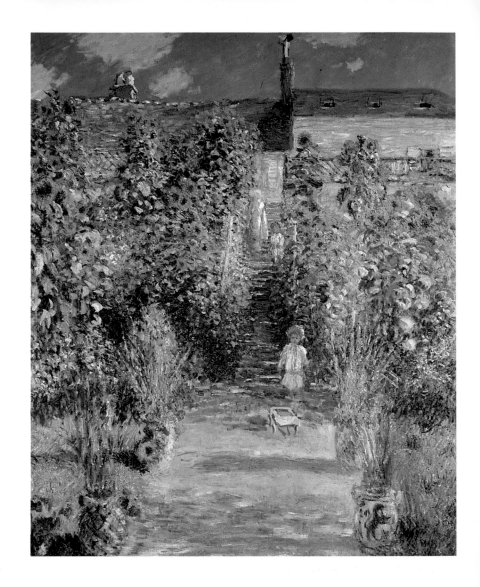

The Garden at Vétheuil 1880

58½ x 46¾ in

Oil on canvas

National Gallery of Art, Washington

In this flower garden in full summer, Monet employed a richer and brighter range of colors than he had used before, with particular emphasis on the yellows of the sunflowers. The intensity of this experiment perhaps prepared him for the Mediterranean trip that he made two years later. Monet's brushwork seems more dashing than before, and indicates his desire to make his paint application imitate more exactly the forms he describes.

Monet's second son Michel is on the steps and Jean-Pierre Hoschedé, who may also have been Monet's child, stands in the corridor-like path between the flower-beds. The motif of the small child engulfed by his surroundings was one Monet had employed in an 1875 painting of his eldest son Jean (Musée d'Orsay, Paris). Here the small child dwarfed by the giant sunflower equally suggests Monet's sensitivity to the uncertainties of childhood. The house is still that at Vétheuil, where Camille had died, but the energy of the vegetation suggests that grief was passing.

The Nets 1882

23 1/2 x 31 1/2 in

Oil on canvas

Gemeentemuseum, The Hague

The surface-stressing quality of the brushstrokes in this painting were to influence van Gogh. This tendency to weave brushstrokes over the surface, creating a somewhat flat image, occurs in several of Monet's marine paintings in the early 1880s. Here, the horizontals of the water, rippling with vitality across the surface, are played against the nets. It is a composition full of contrasts: the heaviness of the sea against the delicacy of the nets, the dominance of white crests of waves against dark, solid rock. It returns Monet to one of his earliest themes: that of fishing, but here with the fishermen excluded from the scene.

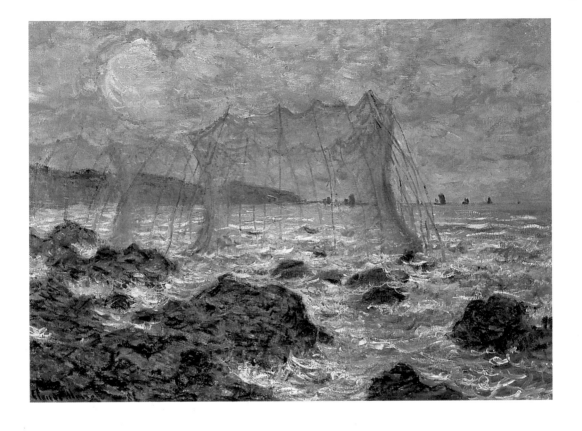

Villas at Bordighera 1884

28½ x 36 in

Oil on canvas

Museum of Art, Santa Barbara, California

Monet's first encounter with the richness and color of Mediterranean light and vegetation was striking. But he had to struggle with it. The bottom of the painting is densely filled with spiky, sharp-edged vegetation in high-key blues, greens, reds, and ochres. The top is more softly focused and dominated by bluey mauve. Although Monet succeeds in mastering the brushstrokes necessary to convey hard forms against soft, the insistent shapes of the buildings seem a necessary frame to hold the burgeoning vegetation under visual control. In the last analysis, Monet was not in spirit a Mediterranean man. He instinctively preferred the rapidly changing climate of the north to the flatter, harsher light of the south. It is significant that there is no visual testimony of his experience of military service in Algeria in 1861.

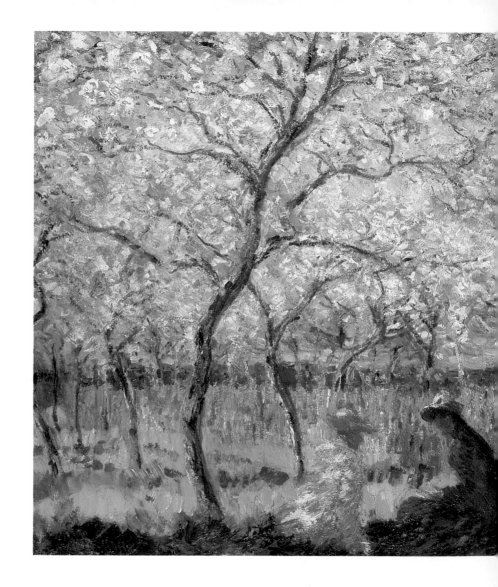

Spring 1886
25¼ x 31½ in
Oil on canvas
Fitzwilliam Museum, Cambridge

This painting, with its extraordinary explosion of white blossom in the air, creates the effect of the bursting abundance of spring. The brushstrokes seem to compete with one another to evoke the irrepressible force of nature. But in attempting to combine nature in full display with figures, and to keep both foreground and background in focus, Monet set himself an enormously difficult task, and he did not entirely succeed in adjusting his strokes to convey such a diversity. Compositional structures are tested almost to destruction – the horizontal emphasis of the fence is blurred, and the figures come near to decomposition. The painting suggests great energy, but it is easy to feel that Monet was not fully in control.

Rocks at Port-Coton with the Lion Rock 1886

25$\frac{1}{4}$ x 31$\frac{1}{2}$ in

Oil on canvas

Fitzwilliam Museum, Cambridge

This is one of the masterpieces among the numerous paintings that Monet made at Belle-Île. It is almost wilful in its introduction of difficult problems, which are then miraculously resolved. It is a near-twilight scene, so that the massive rocks lose their substance and become a flat surface among other flat surfaces; in contrast, the waves take on rocklike substance. In an acrobatic balancing act between verticals and horizontals, Monet plays the strongly silhouetted vertical edge against the stretch of water beyond by aligning the cliff-top with the horizon and creating a breathtakingly taut juxtaposition of the two.

The energy of the juxtapositions is enhanced by an anthropomorphism that is rare in Monet's work: the lion rock seems crouched as if about to spring, like a manifestation of the choppy sea. Monet was, of course, recording a natural rock formation, but it nonetheless acquires a symbolic force.

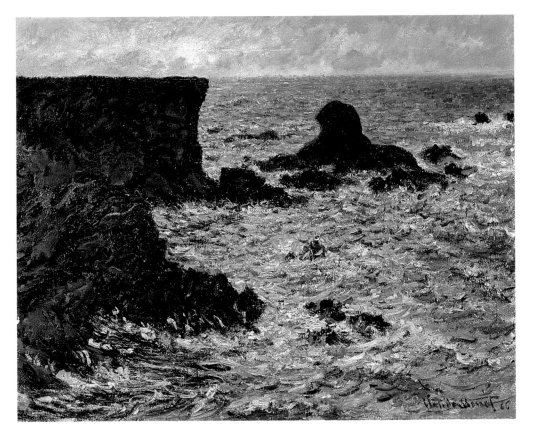

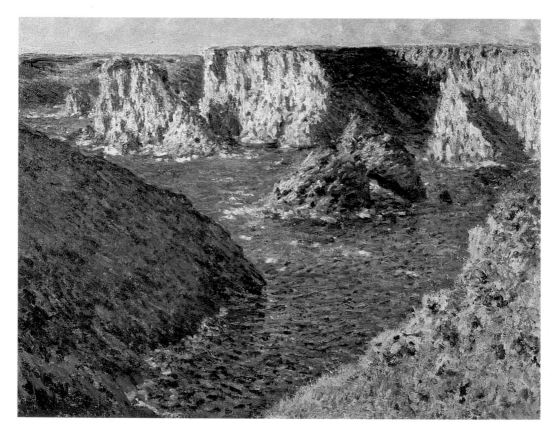

The Rocks of Belle-Île 1886

24½ x 30¾ in

Oil on canvas

Musée Saint-Denis, Rheims

In Monet's view of this inlet in late afternoon, the sea acquires something of the same density as the rocks. Seen at a distance, the forms naturally simplify, and Monet's brushwork is perfectly calibrated to what he wishes to describe. Cunningly, he allows only a thin horizontal of sky to appear at the top of the painting, so that the colors of the sky are projected down into the water, which seems to act as bedding for the bright cliff-faces rising up the picture.

The 1880s and 1890s

Woman with Parasol turned to the Left,

Suzanne Hoschedé 1886

51 x 34¼ in

Oil on canvas

Musée d'Orsay, Paris

In 1886 Monet painted two low-angle views of his stepdaughter Suzanne standing silhouetted against the sky at the top of an embankment at the Île aux Orties. Suzanne was his favorite model among the Hoschedé girls, and despite the appearance of great rapidity in the execution of the two works, and Monet's relative lack of interest in portraits, the artist is said to have exhausted her with the long poses he demanded. The two paintings are a pair, with Suzanne facing in opposite directions, and Monet always kept them.

In this work, Monet recalled a painting he had made a decade earlier in 1875 of Camille and their son Jean. The picture of Suzanne is painted in a softer, less plastic style; but for all the vitality and youth that the image projects, Suzanne, too, was to die prematurely in 1899, at the age of 33, a year older than Camille.

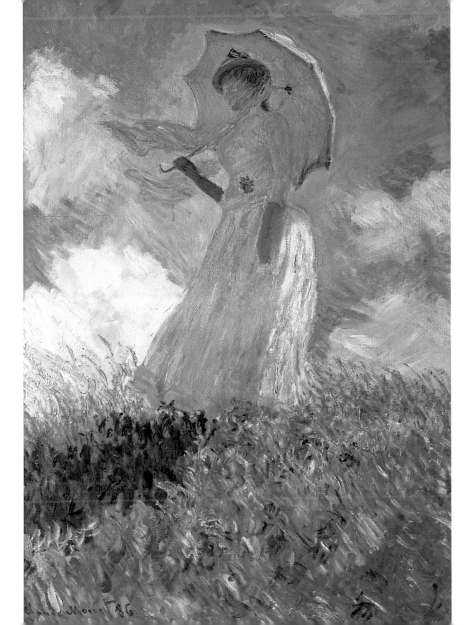

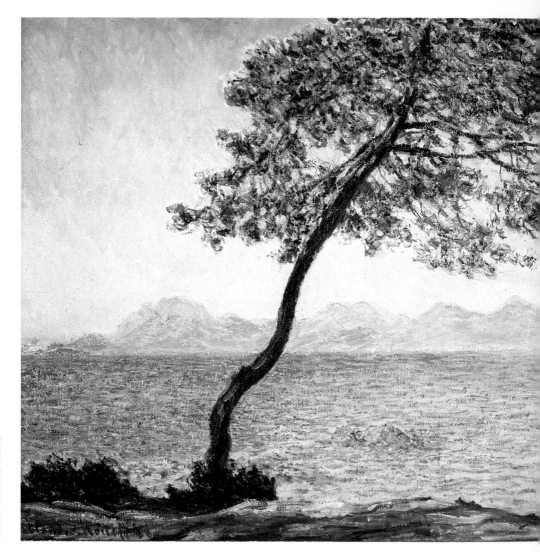

Antibes 1888
25¼ x 36 in
Oil on canvas
Courtauld Institute Galleries, London

In 1888 Monet paid a last long visit to the south of France. He brought back a large number of different views. Although the Mediterranean was not as central to his vision as to that of his friend Renoir, Monet was nevertheless attracted by the brightness of the light and the intense colors of the vegetation. And this time, his painting is under firmer control than on his first visit, when it tended to be submerged in riots of color. A motif that struck him powerfully was that of the wind-bent pines at the Gulf of Antibes. Here, the tree angling across the surface is a consciously Japanese formulation, but it is more than simply a motif. It has greater intensity than most of Monet's other paintings of this moment, and it may reflect his sense of isolation and homesickness.

Haystacks, or the End of the Summer 1891

23¾ x 39½ in

Oil on canvas

Musée d'Orsay, Paris

These haystacks formed the subject of Monet's first conscious
series of paintings. In part, their solid geometrical forms were
chosen as a way of combating the tendency to disintegration
seen in some of his paintings of the 1880s. But the confinement
was a stimulus. With a remarkable fertility and suppleness of
imagination – added to his intense powers of observation –
Monet was able to wring extreme changes in paintings of the
same simple motif under varied light conditions. Here is the
shimmering effect of a heat haze, rendered in tightly constructed,
closely woven overlays of different colors. The surface becomes
even denser than before, the quantity of pigment laid on the
canvas increases, the richness of color lending the haystacks a
visionary intensity.

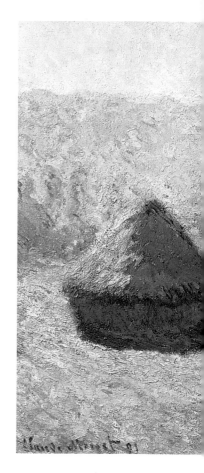

Monet Life and Works

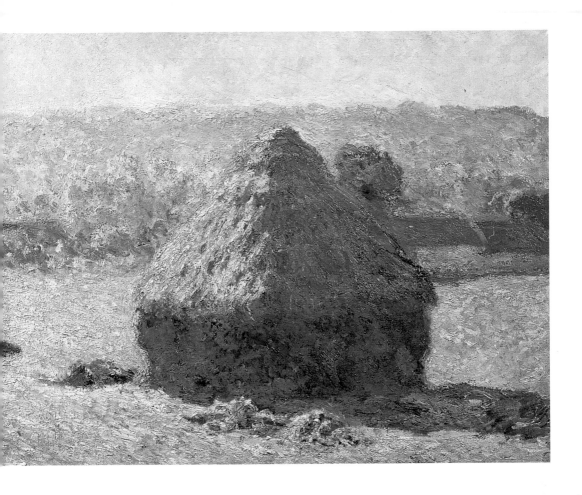

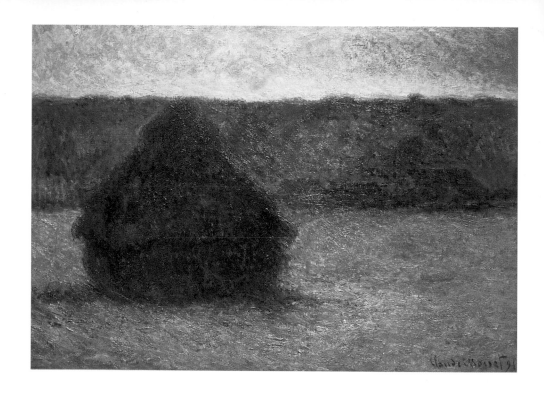

Haystacks at Sunset, Frosty Weather 1891

25¼ x 35¾ cm

Oil on canvas

Private Collection

The top of this haystack coincides precisely with the horizon, giving it a more subdued, earthy quality than those paintings in which the stacks break the skyline. It is as though this stack is huddling down against the cold, an example of Monet's capacity to imbue nature with human mood. But despite the frost, the light of the setting sun brings a warmth and vitality.

The painting is rigorously organized in three broad, horizontal bands of color. In the haystack, the colors separated above are picked up and mixed, like musical themes announced singly and then developed in combination. But the severity of the color-structure is counterpointed by the soft, rich paint application.

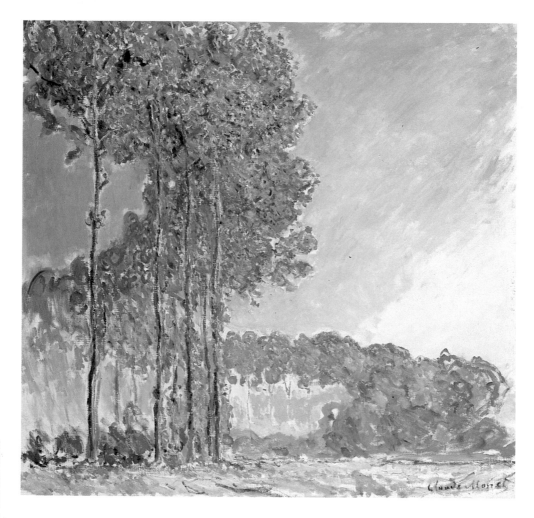

The Poplars 1891

35 x 36¼ in

Oil on canvas

Fitzwilliam Museum, Cambridge

In 1891, Monet was fired by the motif of a line of poplar trees not far from his home. Famously, he paid to have the trees, which were scheduled for logging, temporarily preserved so that he could paint a series of studies of them. The contrast with the density of the haystacks series must have appealed to him, their solidity giving way to slender filaments.

The effect of the present picture particularly, the right-hand side is of a giant brushstroke, like a piece of enlarged Japanese calligraphy. Although one of the simplest of the series coloristically, and among the most thinly painted, Monet exacts an extraordinary dramatic energy from the sweep of trees.

The Three Trees, Autumn 1891

35¾ x 28½ in

Oil on canvas

Private Collection

In this version, Monet chose a viewpoint from which the verticals of the foreground trunks cross the sweeping curves of the receding bank of trees. The arrangement has the clarity of a dollar-sign, but while the movement of lines is, of course, deeply indebted to Japanese woodcuts, the treatment of the surface produces a heightened awareness of texture. The character of the brushstroke and the paint itself compete with our sense of what is described. We become absorbed in slanting strokes of bright green along the riverbank – and their contrast with the swirling yellow patches on the crowns of the spindly trees. The cut-off tops of the foremost trees, their thin trunks, and thin reflections, segment the canvas, playing against the vibrating horizontals of yellow and green. As in the *Haystacks*, every hue is gathered and mingled in the foreground section – here, in the reflections in the water.

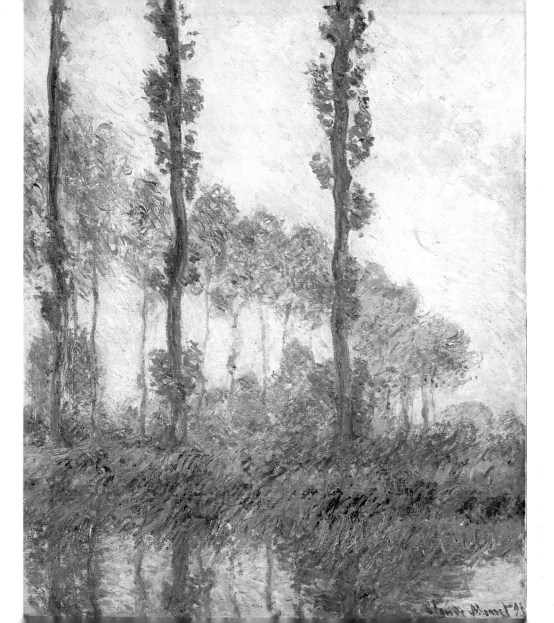

Claude Monet 91

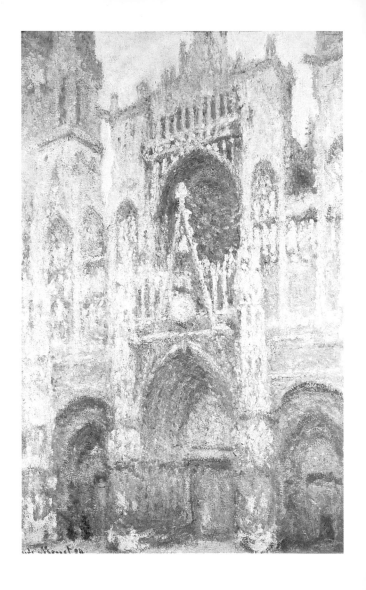

Rouen Cathedral, The West Portal: Dull Weather 1894

39 x 25¼ in

Oil on canvas

Musée d'Orsay, Paris

In 1892 and 1893, Monet painted a series of canvases of the façade of Rouen Cathedral, studying it from two different angles. He worked them up further in his studio and, in 1895, exhibited 20 of them to great success. Although Monet was not religious, he was deeply attached to France's great period of Gothic architecture, and his works struck a powerful chord in a period of intense religious revival. His viewpoint, unusually close to the façade, creates a cathedral of looming grandeur; yet Monet's framings, in their unexpected truncations and apparent lack of balance, give an elastic, unoppressive quality to the structure.

In the cathedral series, for the first time Monet showed how rapidly and dramatically architecture could change color under different lights. Here the palette is a silvery grisaille.

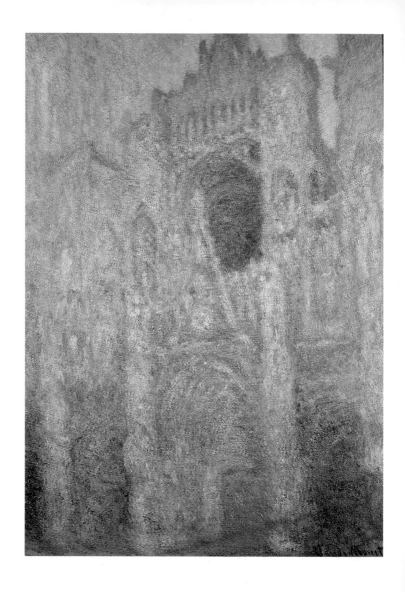

Rouen Cathedral 1891

41¼ x 28½ in

Oil on canvas

Sterling and Francine Clark Art Institute, Williamstown

In this version, warmth radiates from the cathedral. Although the arrangement is very similar to that of the preceding painting, it is more broadly handled and radically different in its coloring of rose and pinks, and in its mood. The façade is a screen on which nature projects her different coloristic effects. The changes of light successively erode some parts of the façade and valorize others, and then they reverse the process. They testify simultaneously to the cathedral's subjection to light and its enduring capacity to transform itself. This series in particular has something of the quality of a lung contracting and expanding.

The Late Paintings

PAINTINGS BETWEEN 1899 AND 1923

Waterloo Bridge 1902

25¼ x 39 in

Oil on canvas

Hamburger Kunsthalle, Hamburg

Staying in the Savoy Hotel on several occasions between 1899 and 1901, Monet could look downstream at Waterloo Bridge and upstream at Hungerford Bridge. He painted several canvases of both. For the first time in many years, Monet returned to an industrial cityscape, but one modulated and softened by the London fogs that so excited and tormented him. The dark bustle of figures and carriages crossing the bridge is complemented by the white smoke from the factory chimneys on the South Bank and beyond. But all this activity is rendered by Monet as though it was a natural process: his love of landscape did not preclude a fascination with an industrial city.

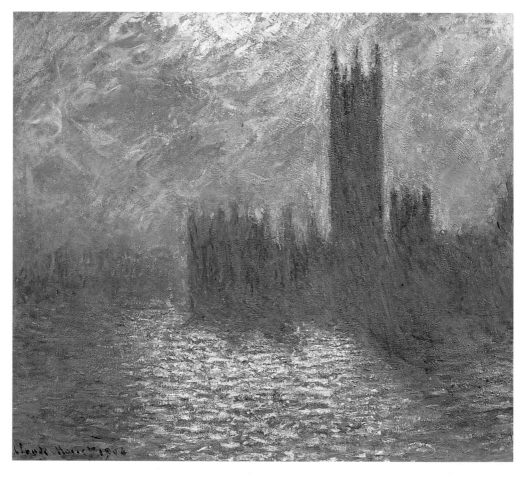

Houses of Parliament 1904

31½ x 36 in

Oil on canvas

Musée des Beaux-Arts, Lille

As well as London's bridges, Monet also painted many versions
of the Houses of Parliament, a more arresting motif. Like the
paintings of the bridges, his views of Parliament were sketched
on the spot between 1899 and 1901 and worked up later in the
studio; they were exhibited together in 1904. The main motif is
displaced to the right, seeming to advance across the Thames
like a barge. One of Monet's central poetic resources was to
envision the static as mobile, and the mobile as static. The
painting has strongly symbolist qualities: the tower rises towards
the sun like a plant.

It is interesting to compare this image with *The Thames below
Westminster* (*see pages 52–3*), painted 30 years earlier. The
arrangement of the 1904 picture is much less rigorous, with a
soft, amorphous blending of colors throughout, as though the
building is condensing out of the London fogs.

The Bridge over the Water-Lily Pond 1899

34¾ x 36 in

Oil on canvas

National Gallery, London

Monet had a bridge built over his lily-pond in the early 1890s, but he did not choose it as a pictorial subject until 1899. Its Japanese-style structure demonstrates the interest that Japanese art retained for him, and his exploitation of it as a pictorial motif indicates his continuing fascination with bridges, instruments of passage. This surely reveals something of Monet's desire to connect with others – especially his wife Alice, distraught at the premature death of her daughter Suzanne.

In this painting and its companions there is a conscious tension between the clarity of the design of the man-made and the fecundity of nature: here the density of the lilies and rushes turn the water into a meadow.

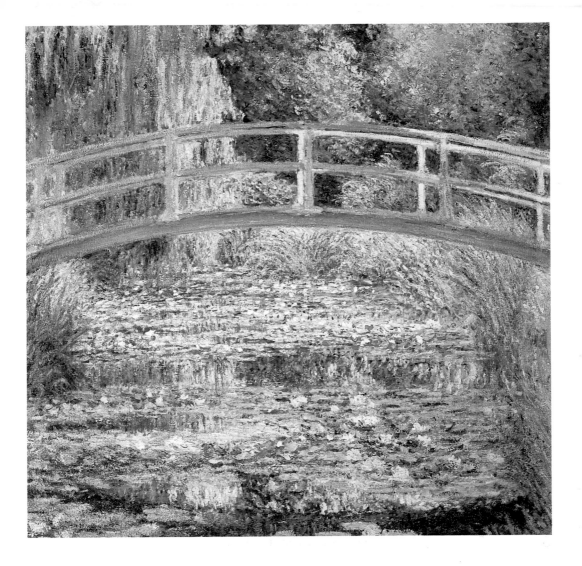

Water-lilies 1904

35 x 36¼ in

Oil on canvas

Musée des Beaux-Arts André Malraux, Le Havre

In setting the bright lily-pads in dark water, created by the reflection of overhanging foliage, Monet suggested the effect of a constellation of planets in the night sky. The bright points float in an apparently gravitational field on the surface, the chosen angle of vision allowing near and far to be comprehended in a single curve. Great attention is paid to the richness of the flowers, Monet here making distinctions of substance that are less evident in the later large-scale treatments.

The small pictures of water-lilies are sometimes criticized for their prettiness; but their miraculous fluency of technique reveals Monet's pleasure in painting them. They are among his most relaxed works and they express, in a personal way, something of the mood of the Belle Époque.

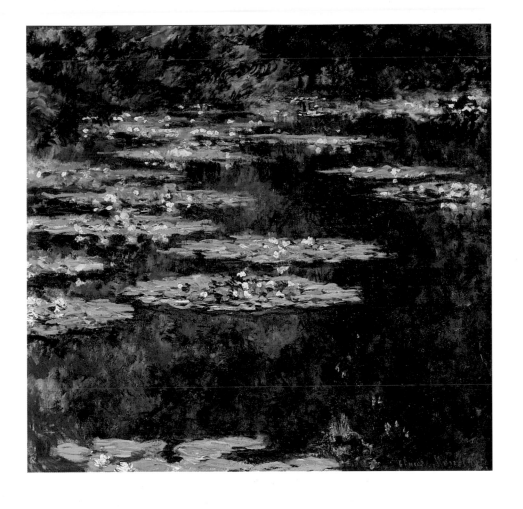

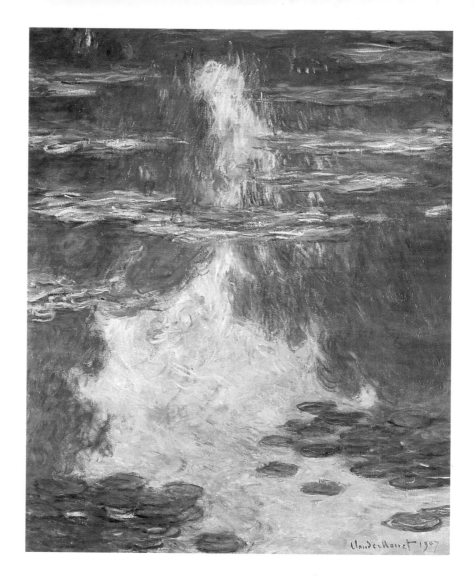

Water-lilies 1907

39 x 31½ in

Oil on canvas

Kuboso Memorial Museum of Art, Osaka

Monet up-ended the canvas and portrayed a section of his pond in vertical orientation. The substantiality of the flowers and lily-pads is much reduced: they are employed more to establish a sequence of horizontal layers and to stabilize the viewer's angle of vision than as individual motifs. Reflection dominates: the yellow of the setting sun turns the water a cool gold, and the undulations of the willow branches are like vertical tendrils waving within it. All is slow movement and evanescence, and the surface of the pond is formed of reflections and subaquatic forms. In this painting, everything becomes something else in an alchemy of transformation.

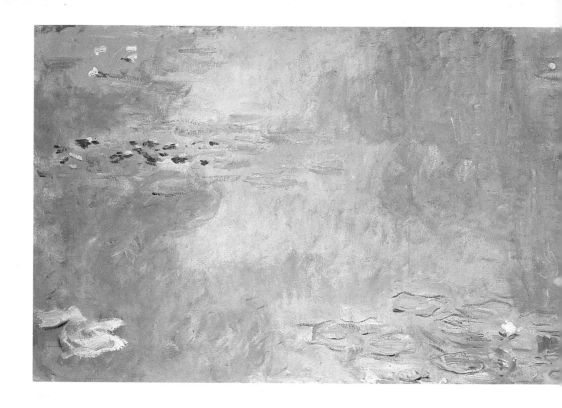

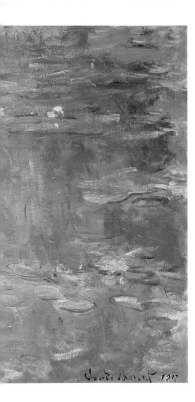

Water-lilies 1917

39 x 78 in

Oil on canvas

Musée des Beaux-Arts, Nantes

This painting was given to the museum by Monet to encourage modern art. He was already working on the large canvases and it is uncertain whether this was a by-product of that scheme or a sketch for a larger version that was never painted. It has the delicacy and gracefulness of the 1904–7 series, but the format is panoramic and therefore more fully absorbs the viewer. It combines the surface life of the leaves and flowers with the reflections of the spring foliage of the willows, so that the surface seems as much grass as water. It is lightly and airily executed, unlike the larger paintings that Monet worked and reworked. Even in the midst of the war, and following many tragedies in his own family, Monet could still produce painting of verve and joyousness.

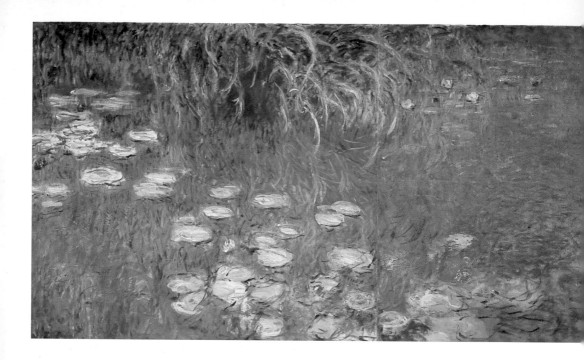

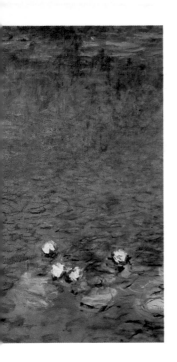

Water-lilies: Morning 1914–18

Whole 768¼ x 495¾ in

Oil on canvas

Musée de l'Orangerie, Paris

Left section

In 1914 Monet resolved to undertake a project that he had considered for some years: to create a large series of life-size views of his lily-pond. Planning and painting the series during the First World War, in part as a psychological antidote to the slaughter, Monet finally decided in 1918, after much discussion with Clemenceau, to donate the works to the French state. Although his motive was celebration of the Allied victory, no triumphalism is evident in his paintings: indeed, their overall effect is sober and ruminative.

After an abortive attempt to build a pavilion for the paintings in the garden of Rodin's house, the Orangerie, a 19th-century building constructed in imitation of the 18th-century Jeu de Paume at the end of the Tuileries gardens, was selected as the location. Monet gradually enlarged his gift: he finally presented the state with 22 canvases, which fully occupy the walls of two adjacent oval rooms.

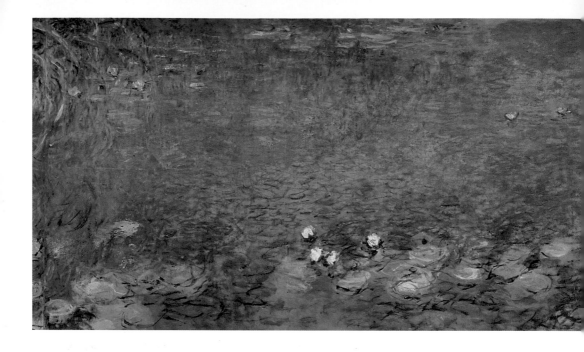

Water-lilies: Morning 1914–18

Whole 768¼ x 495¾ in

Oil on canvas

Musée de l'Orangerie, Paris

Center section

Although Monet was involved in its planning, the final installation was completed only after his death. His rooms were opened with fanfares in May 1927, but interested neither the public nor other artists. A year later, as he noted sadly, Clemenceau found himself alone in one of the rooms. It was only in the 1960s that there was renewed interest in the scheme, in part because the canvases had come to be seen as harbingers of abstract expressionism.

However, Monet's aim was neither expressionist nor abstract. It was to re-create in the viewer the experience of a type of nature that encouraged calm, reverie, and reflection. Sometimes seen from a short distance, framed between the trunks of the weeping willows, but more often focused on the surface of the water with no bank visible, the surface of the lily-pond is both transparent membrane and mirror. The sky and the willow trees are reflected in the water, on which float lily-pads and flowers, and below the surface the tendrils of aquatic plants merge into the reflections of exterior vegetation. The viewer's eyes are involved in a perpetual cycle from one level to another, while remaining aware that all the levels are identical.

The Late Paintings

Water-lilies: Morning 1914–18

Whole 768¼ x 495¾ in

Oil on canvas

Musée de l'Orangerie, Paris

Right section

A common motif in Romantic paintings was the representation of a melancholy figure seated by a pond, gazing into its depths. Monet's paintings re-create this experience for the viewer, but without the melancholy. Indeed, the mood of the series in the Orangerie is one of calm and refreshment. The viewer senses that all aspects of life are being brought into balance with one another, and mental agitation is soon transformed into meditation, reverie, and dream. This is in part achieved by the uncertainty as to whether the forms are on, under, or above the surface, but it is also a consequence of the Eden-like power of Monet's series, his vision of a nature that is productive, revivifying, and harmonious. Life is generated from water, and the dissolution of consciousness experienced by the viewer is neither disorientating nor alarming, rather it conveys a mysterious completeness.

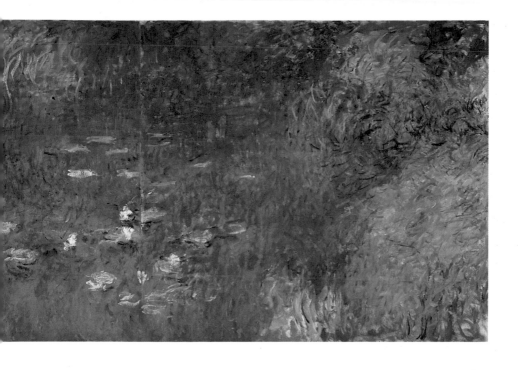

The Japanese Bridge c.1923

34¾ x 45¼ in

Oil on canvas

Minneapolis Institute of Arts, Minneapolis

This view of the Japanese-style bridge over Monet's lily-pond
shows it with the upper arch it had acquired when it was
surmounted with a trellis. But the geometrical enhancement was
counteracted by the plants trained over it, which gradually came
to submerge the man-made forms. This picture is one of a series
painted when Monet's problem with cataracts was becoming
acute: at first he seems to have seen all colors as part of a
blue-green range; by the time this work was painted, they had
switched to hot reds and yellows. The effect is incandescent,
reminiscent of the blazing sunsets of the aged J. M. W. Turner.
As the sun ravages Monet's eyes, so nature takes over human
structures. But despite his diminishing control, Monet still
displays an effort to get down to what he knows best. The turbid
handling of paint opens the way to the action painting of artists
such as Jackson Pollock.

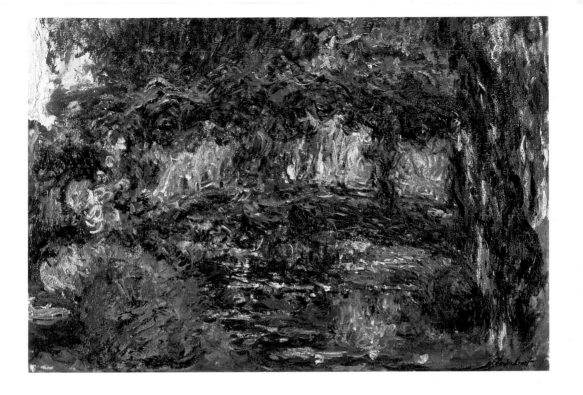

Chronology

1840 Monet born in Paris

1845 Family moves to Le Havre, where Boudin introduces Monet to open-air painting

1859 Goes to Paris, where attends the Académie Suisse

1862 Enters the studio of Charles Gleyre, where probably remains until spring 1864; comes into contact with Bazille, Renoir and Sisley

1865 Two seascapes accepted at the Paris Salon in 1865; *Dejeuner sur l'Herbe* praised by Courbet

1866 Success at the Salon with *Camille*; meets Manet

1867 *Women in the Garden* refused by the Salon; Camille Doncieux gives birth to first child, Jean. Forced by financial troubles to stay with his family in Le Havre

1868-70 Wins Silver medal at the International maritime exhibition at Le Havre; 1869–70 submissions to the Salon are rejected. Marries Camille and goes to London, where meets the dealer Durand-Ruel

1871 Work rejected by the Royal Academy; visits Zaandam in Holland; settles at Argentueil; Durand-Ruel begins to buy many of his paintings

1874 *Impression, Sunrise* shown at first exhibition of the Société Anonyme, giving rise to the name Impressionist

1878 Leaves Argenteuil for Paris; birth of second child, Michel; moves to Vétheuil

1879 Exhibits in 4th impressionist exhibition; death of Camille

1881 Moves to Poissy with Alice Hoschedé and her children

1883	Paints on the Normandy coast around Etretat; first one-man show at Durand-Ruel Gallery; moves with Alice Hoschedé and family to Giverny	**1896-9**	Works on series of *Early Mornings on the Seine*. Begins first series of water garden paintings in 1899; goes to London, where paints until 1901
1884-9	Painting on the Mediterranean, the Normandy coast and the tulip fields near the Hague. Refuses Légion d'Honneur in 1888; major retrospective exhibition at Georges Petit's gallery in 1889	**1903-8**	Paints second water garden series
		1911	Death of Alice Monet. Cataracts diagnosed in both Monet's eyes the following year
		1914	Builds garden studio to paint the *Water Lily* decorations, presented to the State in 1922
1890-2	Buys the house at Giverny; begins work on grainstacks series. Exhibits poplar trees series in 1892 at Durand-Ruel gallery; begins Rouen cathedral series; marries Alice Hoschedé after death of her husband	**1923**	Cataract operation is partially successful
		1926	Monet dies at Giverny
1893	Begins water garden at Giverny		

Index